Women, Sisters

erica lennard

Women, Sisters

Afterword by Marguerite Duras
Text by Elizabeth Lennard

The Bobbs-Merrill Company, Inc.
Indianapolis/New York

Library of Congress Cataloging in Publication Data
Lennard, Erica.
 Women, sisters.
 Translation of Les femmes, les soeurs.
 1. Photography of women. 2. Women—Portraits.
I. Lennard, Elizabeth. II. Title.
TR681.W6L3813 779'.24'0924 77-15430
ISBN 0-672-52387-6

Women, Sisters

I travel with you and alone,
through perfect moments graced with light
You and I are not the same,
But you are me reflected in these images.

Elizabeth and I are sisters,
We are all sisters. . . .

 Erica

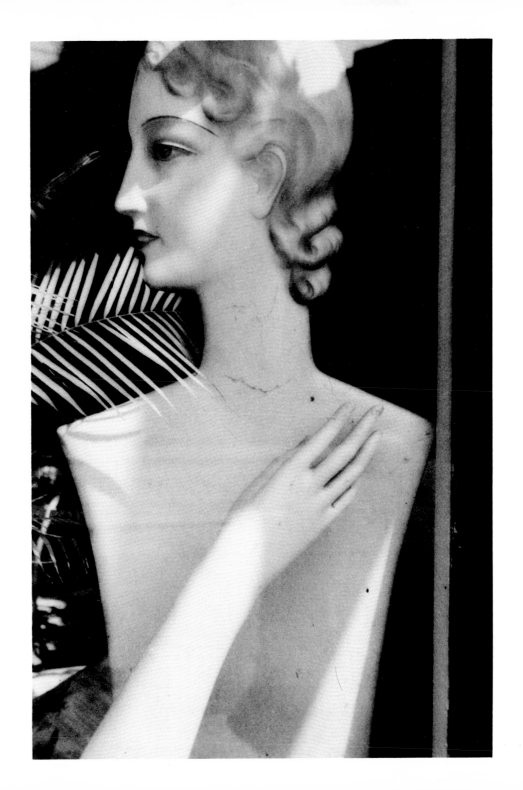

Dear Erica,

A place in time, a place in your life, a place in mine. The face of a fleeting moment: a brisk shadow on the wall penetrates the darkness, or the light; like your name, Erica, a precise sound.

Did I dream of horses? Did I wish to wear my grandmother's dress, or nakedly explore the shores of Greece, playing Aphrodite's children? A child-woman, a girlchild, the day I was outside ready to escape in my big old car.

A woman's desire—we can see it but not its object. An erotic shadow seen and then gone on another moody Parisian day. A pale nude listens to the conch's story. A curve.

You know me: I'm the time you were older and suddenly left alone in a cold bed by your lover somewhere and there was no escape, or that place you never wanted to escape from. Each instant you were desired by everyone, or the moment you wished you were someone else . . . or at least had a pair of their shoes.

I am dressed as a boy, or feeling very feminine. A friend, a bitch, a toy, a joke, a loving pet, a soft word spoken or a loud one left unsaid.

This is a sister-to-sister letter . . .

Love,
Lizzy

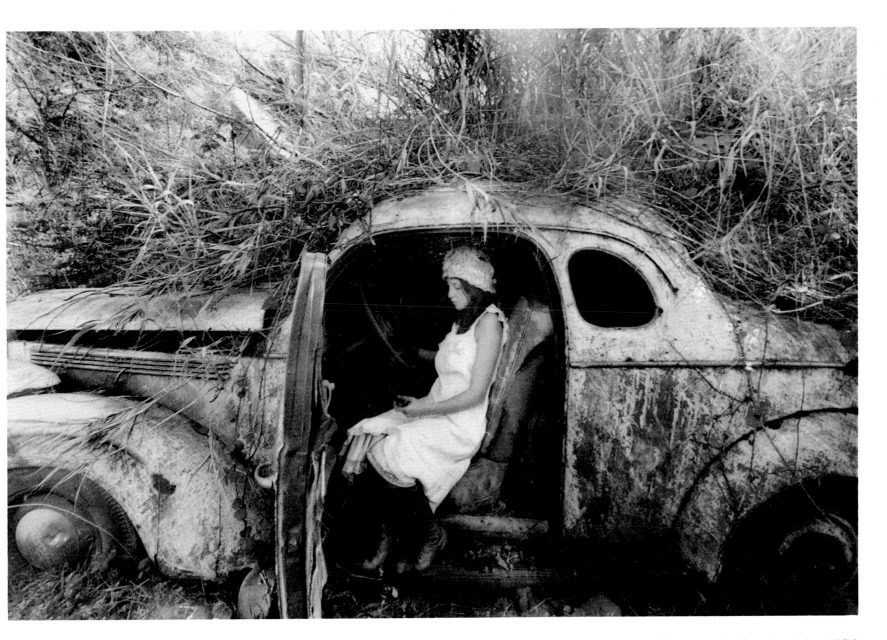

Elizabeth, California, spring 1970

I WAS TWENTY AND YOU WERE SEVENTEEN. . . .

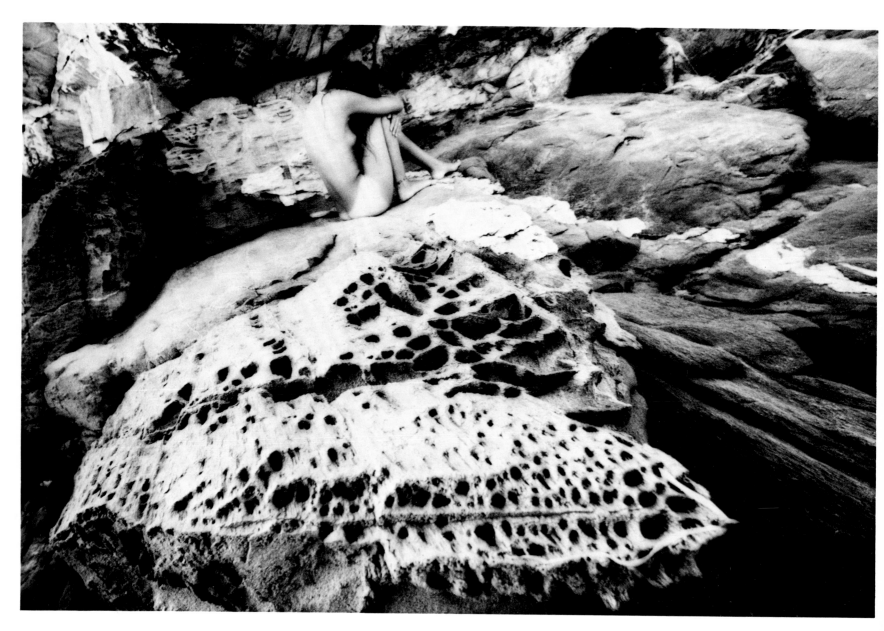

Erica photographed by Elizabeth, Greece, 1970

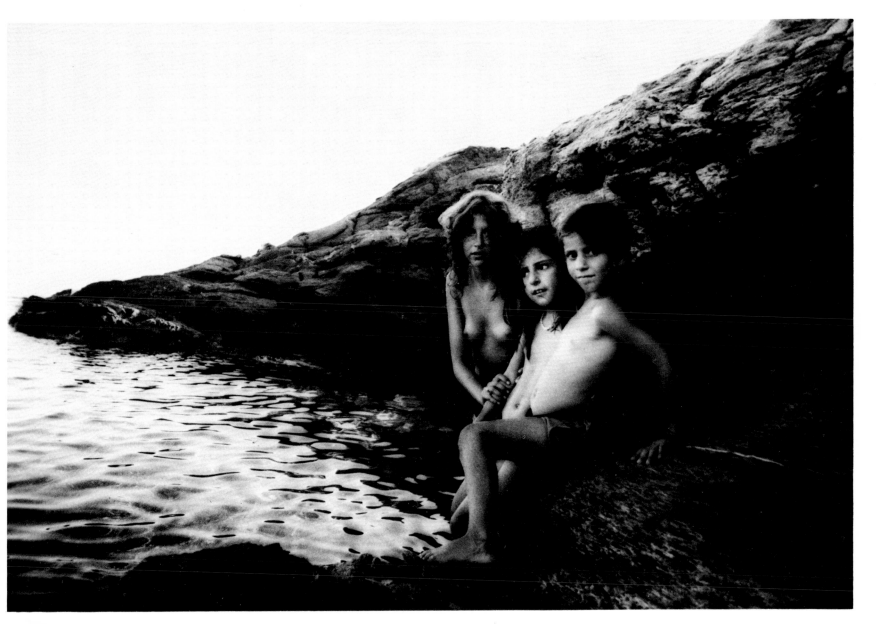

Elizabeth, Greece, summer 1971

my sister

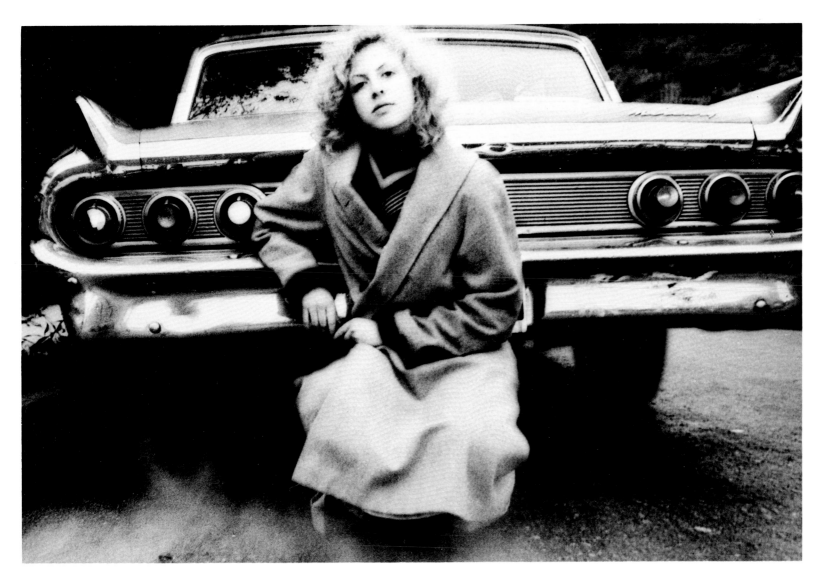

Elizabeth, Mill Valley, California, winter 1973

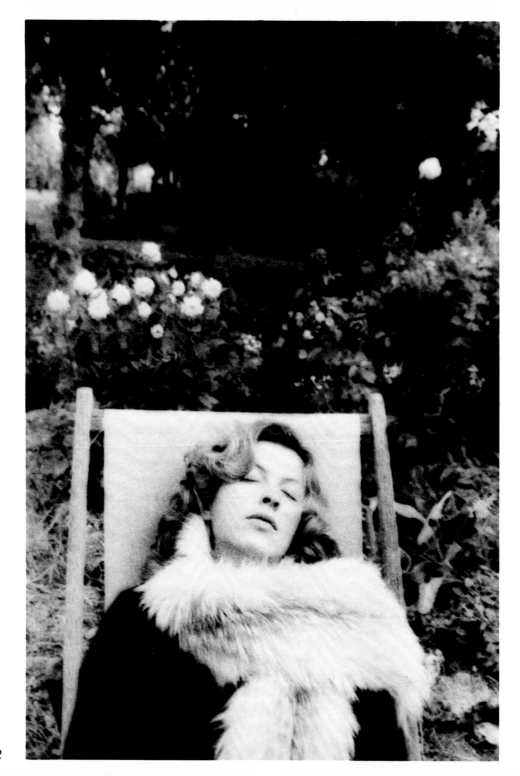

Elizabeth, France, autumn 1972

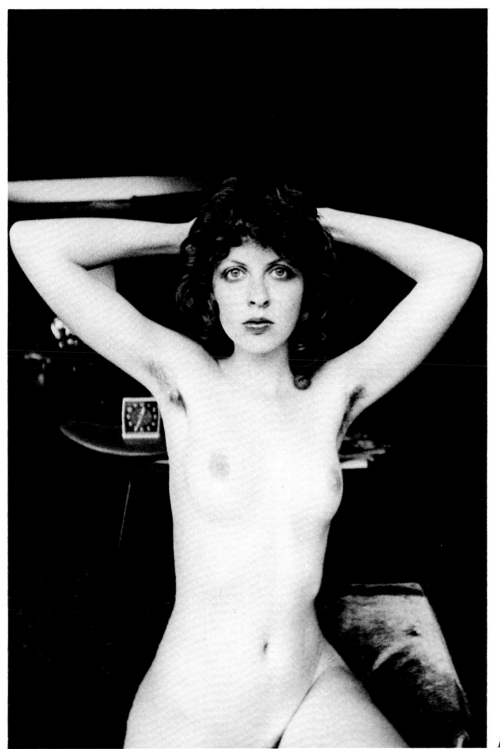

Elizabeth, Hollywood, spring 1972

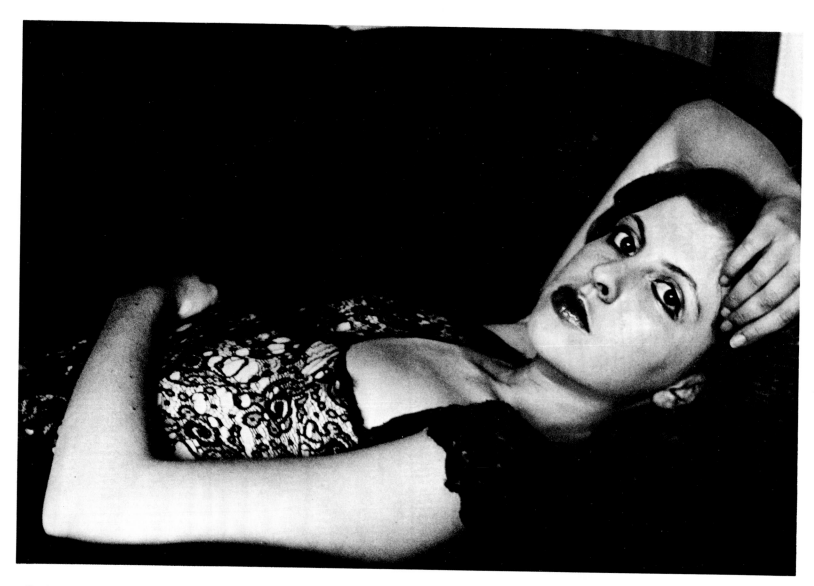

Elizabeth, California, winter 1973

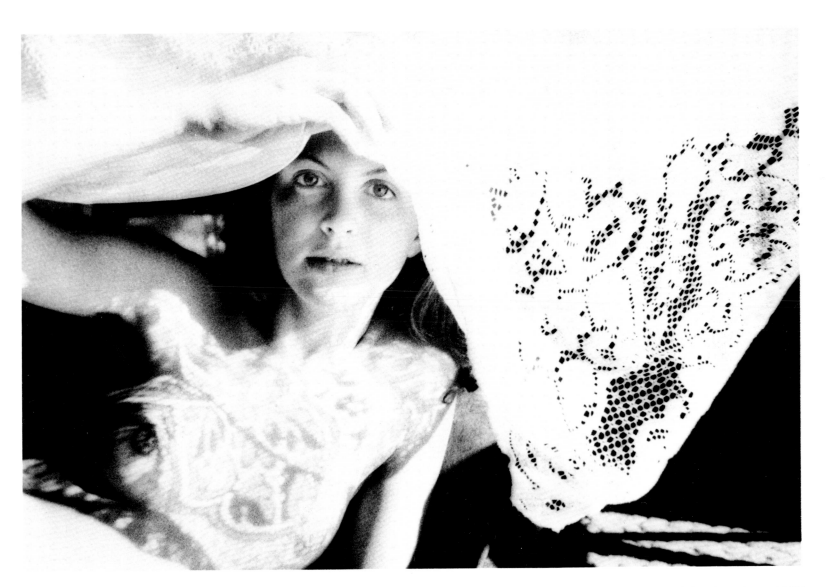

Elizabeth, California, winter 1973

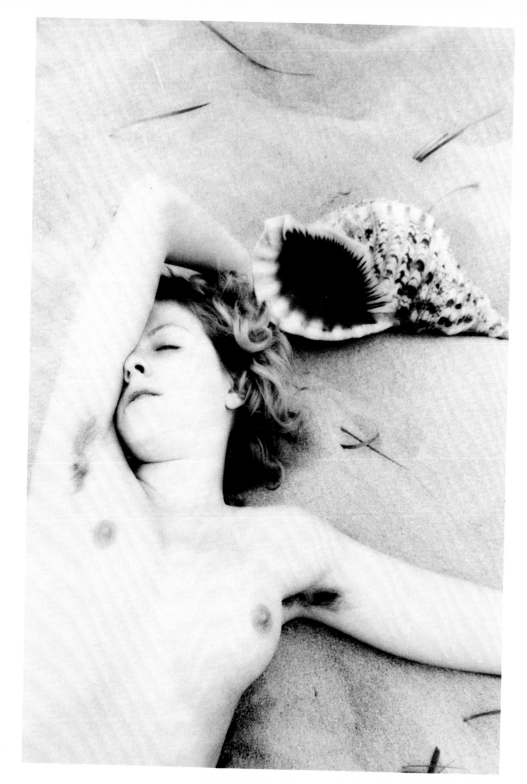

Elizabeth, Stinson Beach,
California, 1973

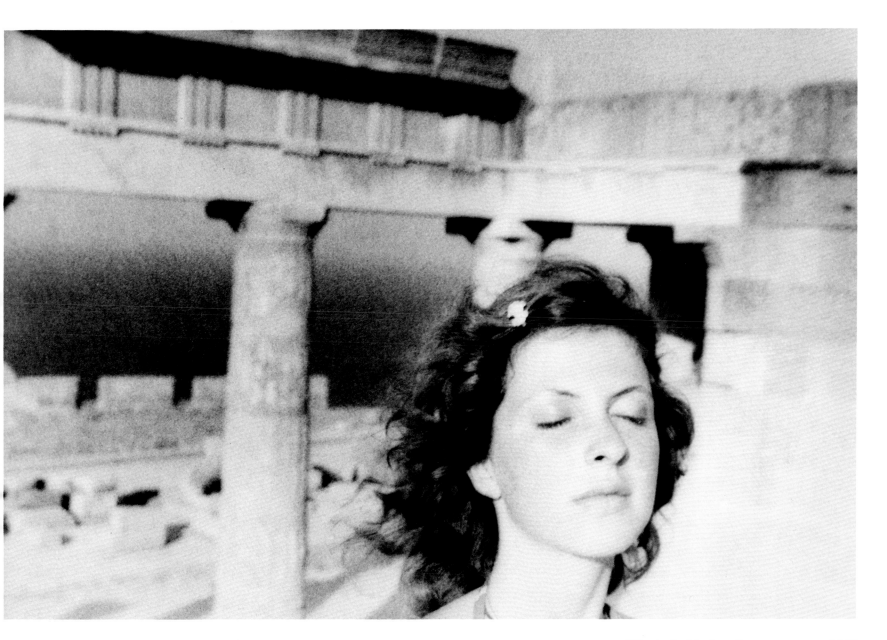

Elizabeth, Lindos, Greece, summer 1973

friends

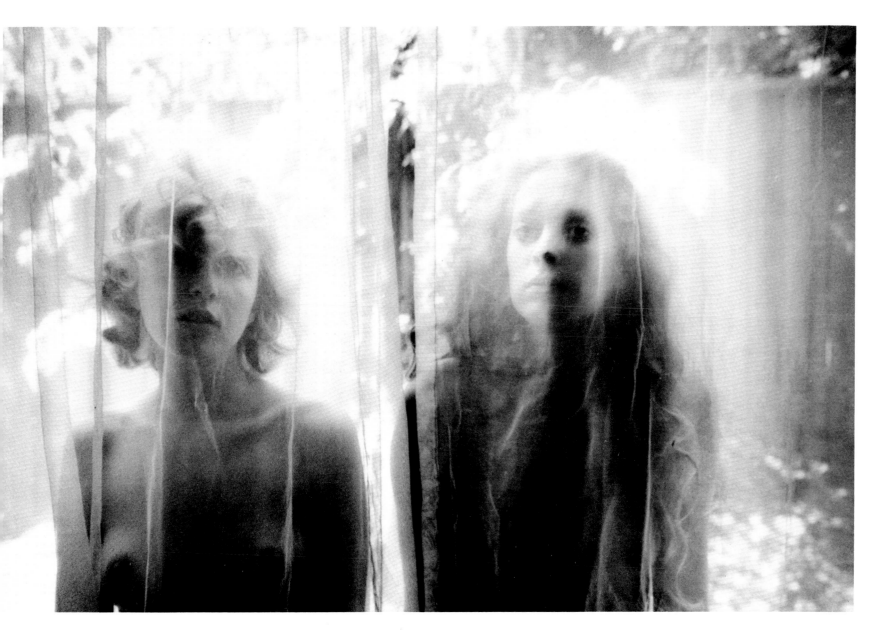

Elizabeth and Tinda, Hollywood, spring 1973

Unnoticed, beauty rests
in some apartment
poorly dressed.

Unnoticed, beauty rests
on someone's floor
until it's not
unnoticed anymore.

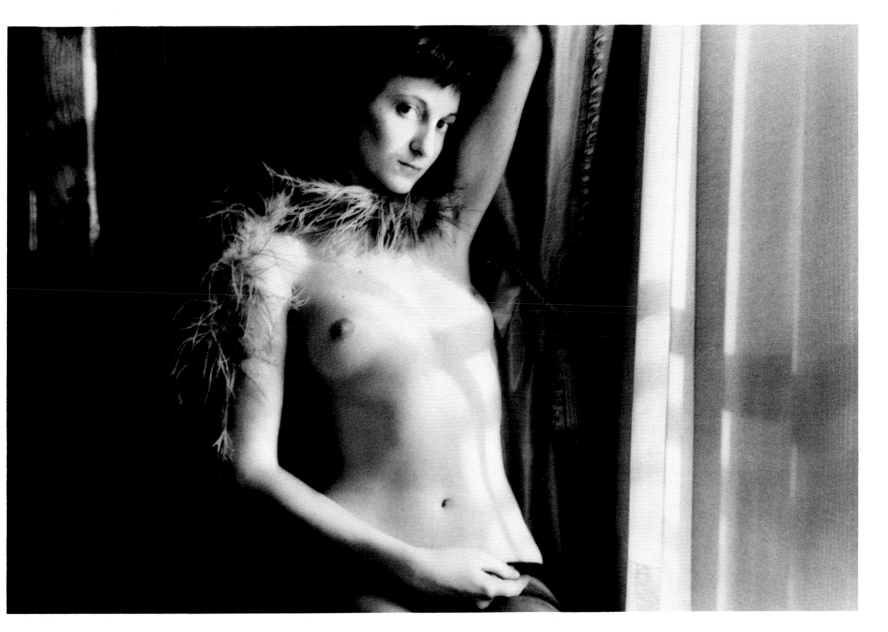

Catherine, Paris, winter 1974

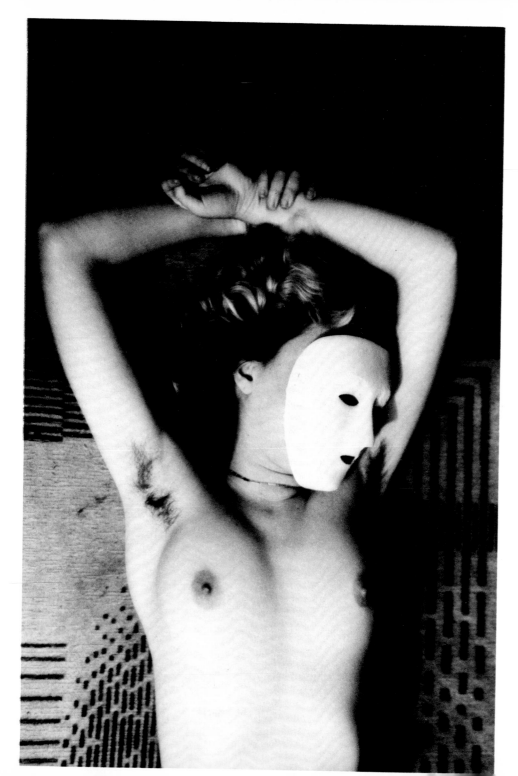

Elizabeth, Paris, winter 1974

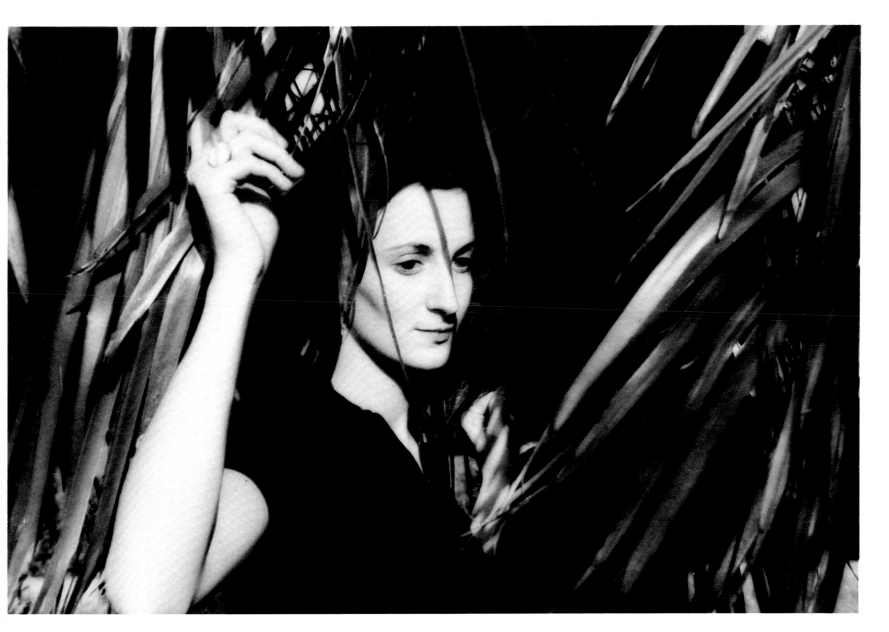

Catherine, Cannes, spring 1974

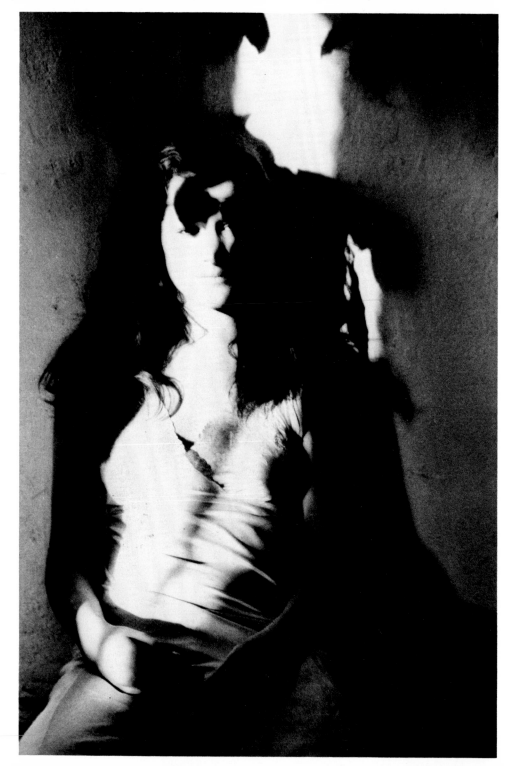

Lisa, New York City, winter 1973

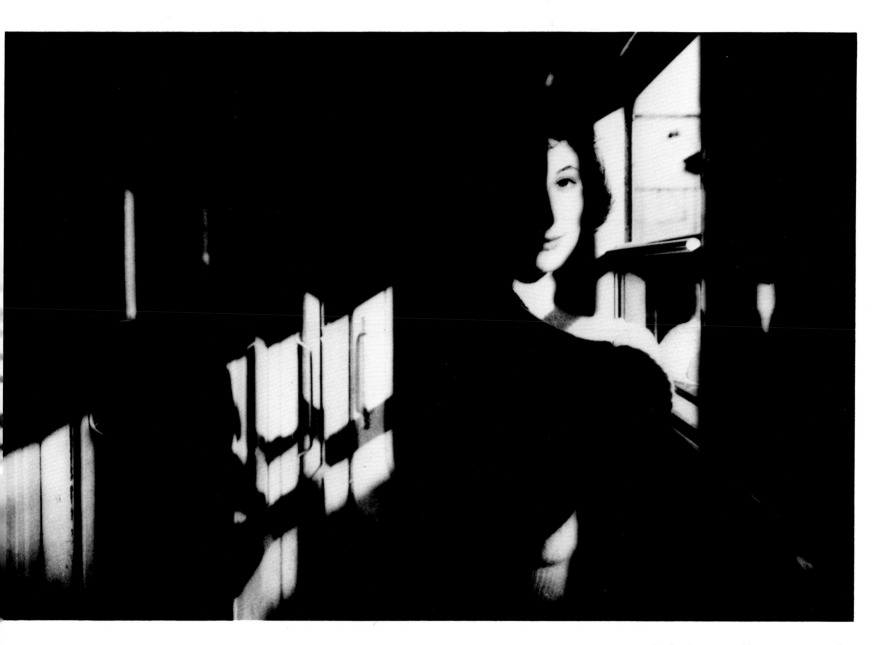

Catherine, traveling, autumn 1974

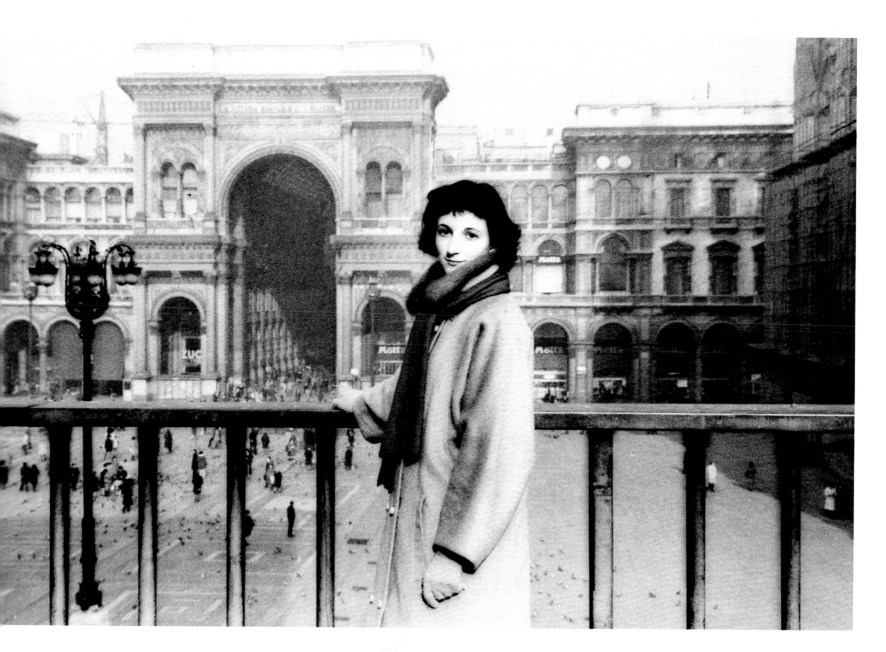

Catherine, Milan, winter 1974

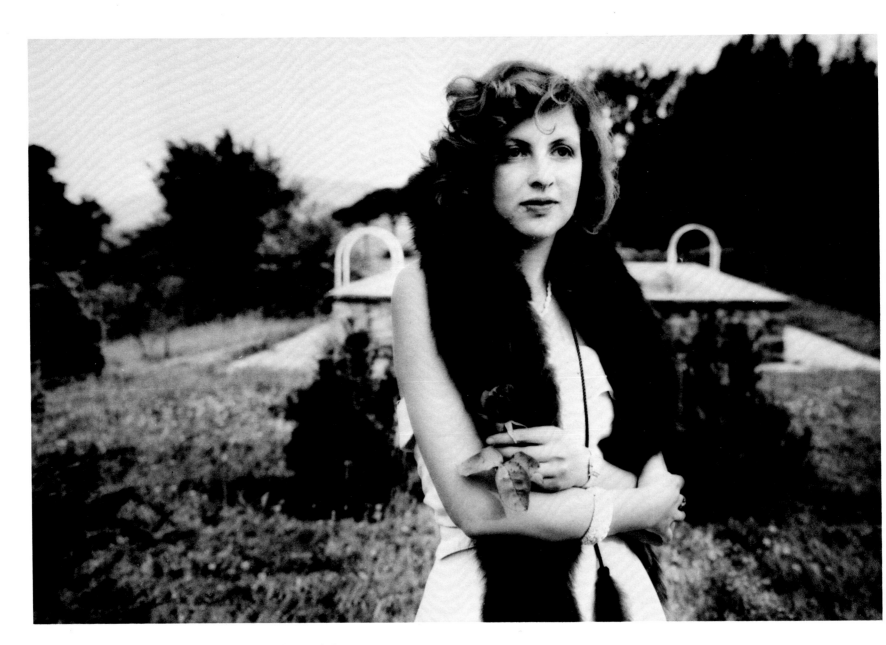

Elizabeth, les Grands Esclans, France, spring 1974

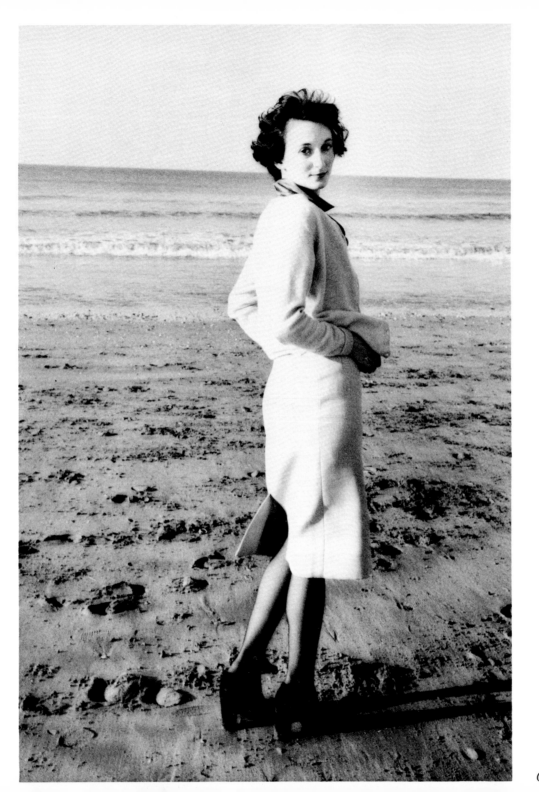

Catherine, Deauville, winter 1974

I woke up,
But never had been sleeping,
Severed the strings
Which never formed
Until they had been broken.

I woke up
But never had been sleeping.

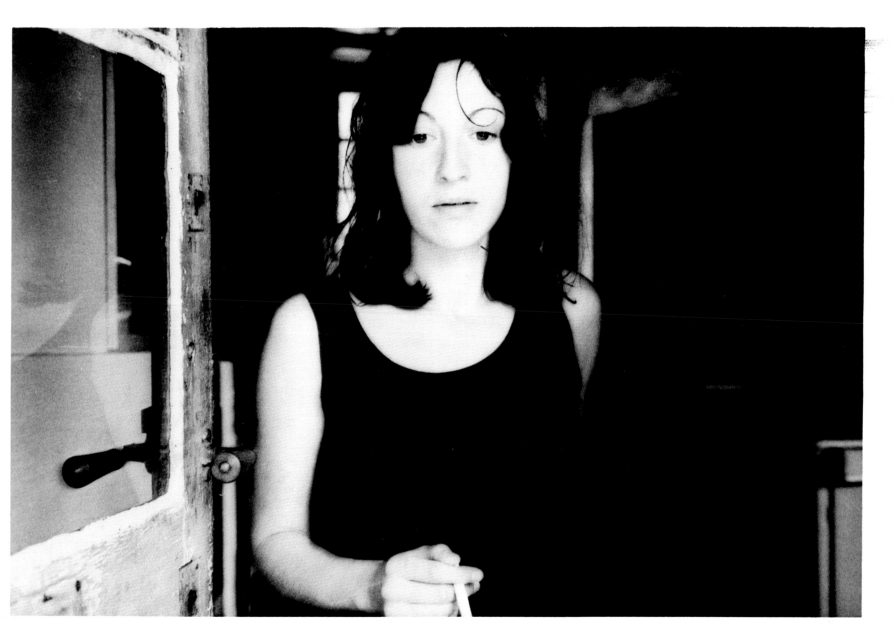

Anne, Neauphle-le-Château, France, summer 1974

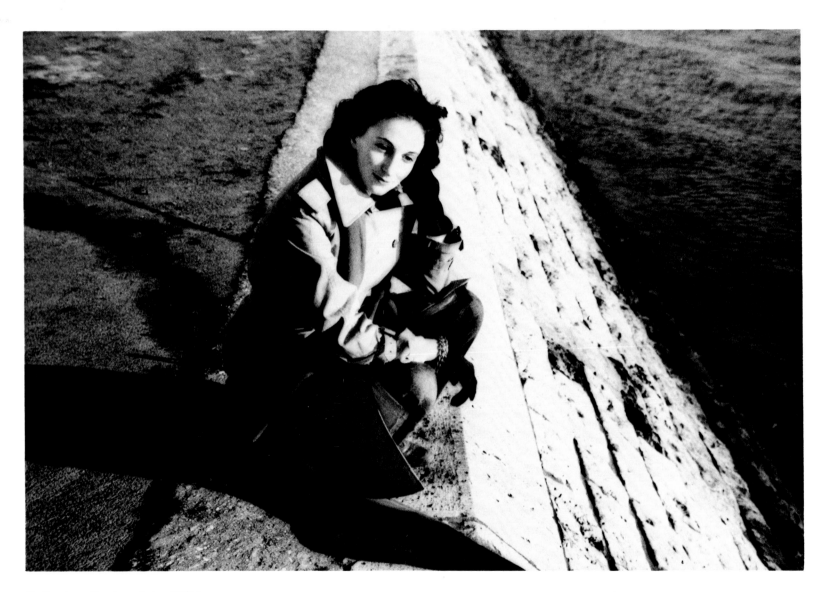

Catherine, Paris, winter 1974

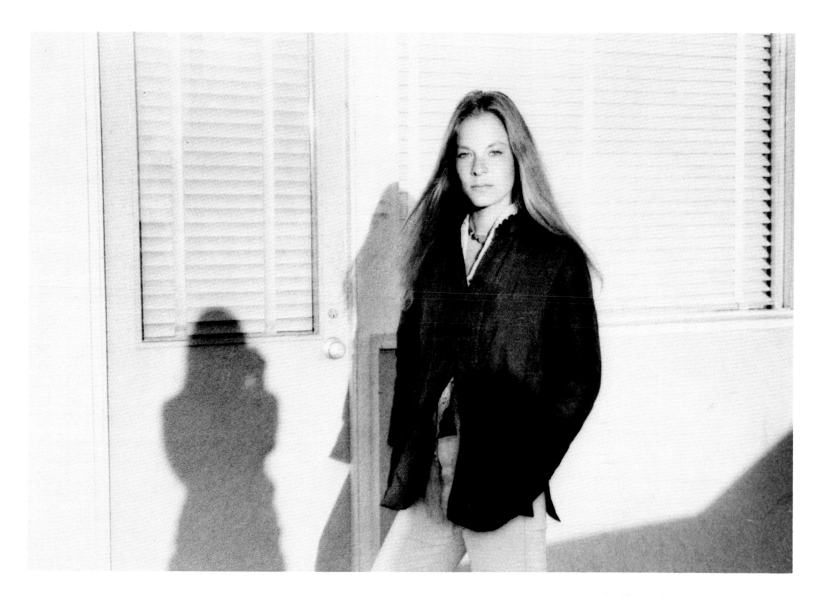

Leslie, California, summer 1974

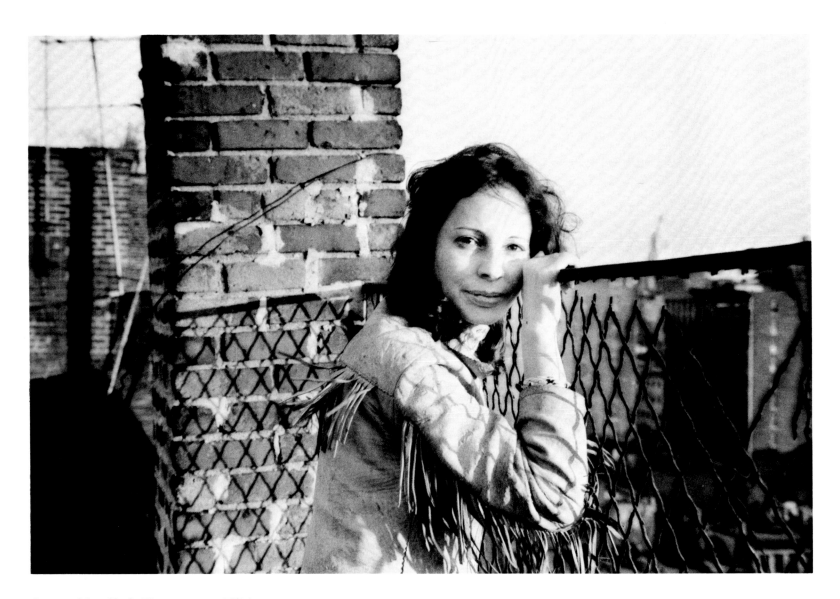

Laura, New York City, autumn 1974

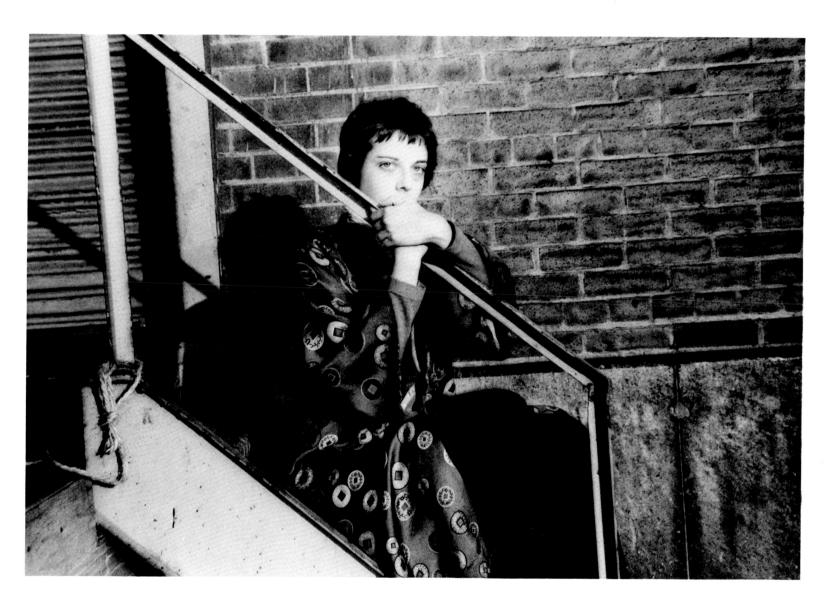

Tessa, New York City, autumn 1974

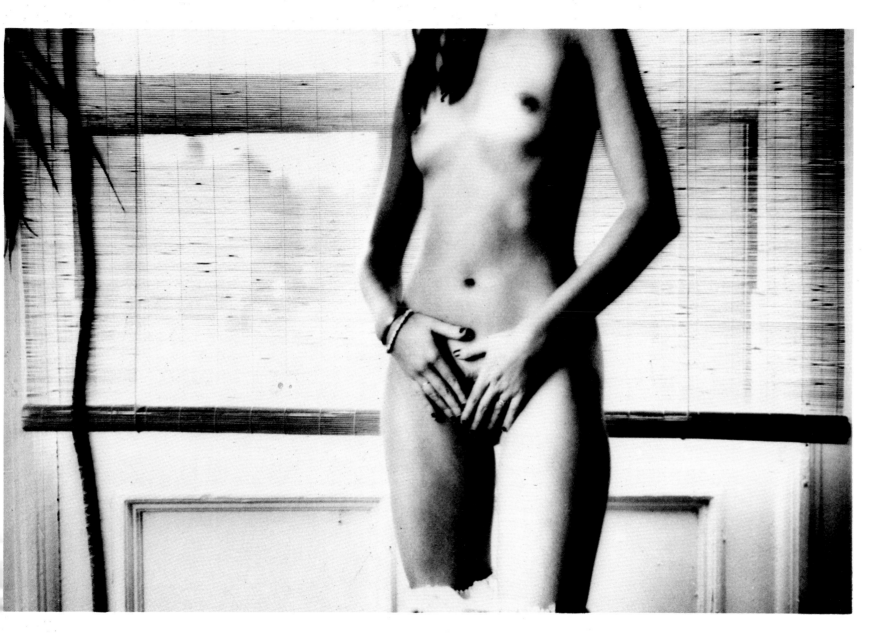

Self-portrait, New York City, autumn 1974

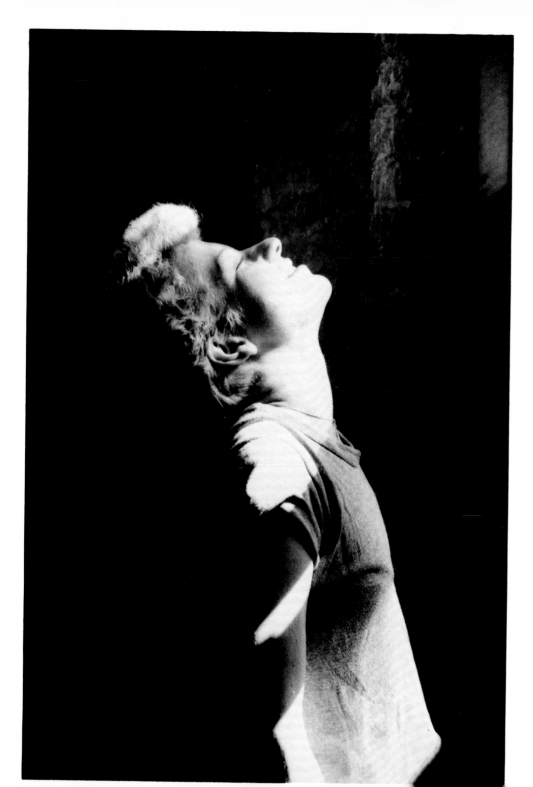

Pooh, New York City, winter 1974

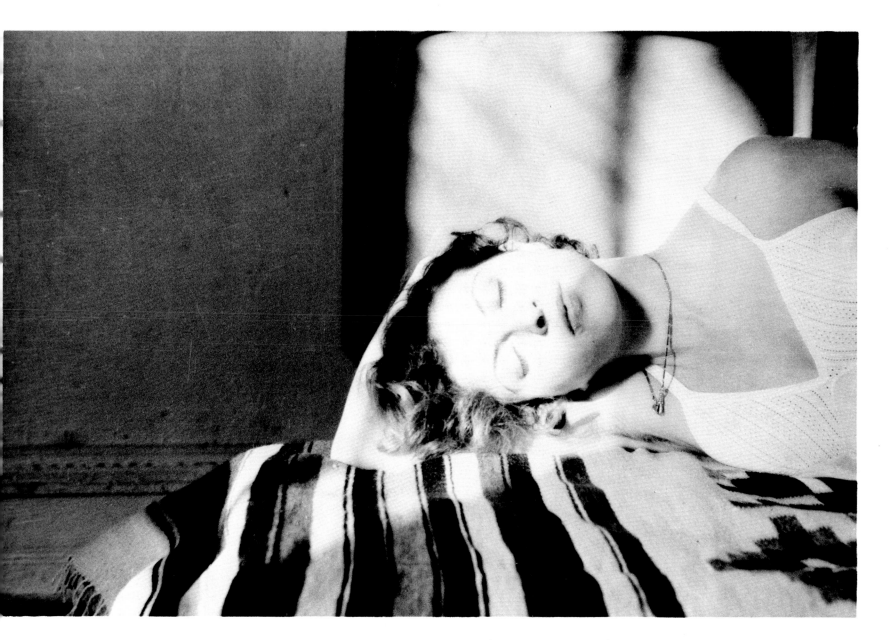

Elizabeth, New York City, winter 1974

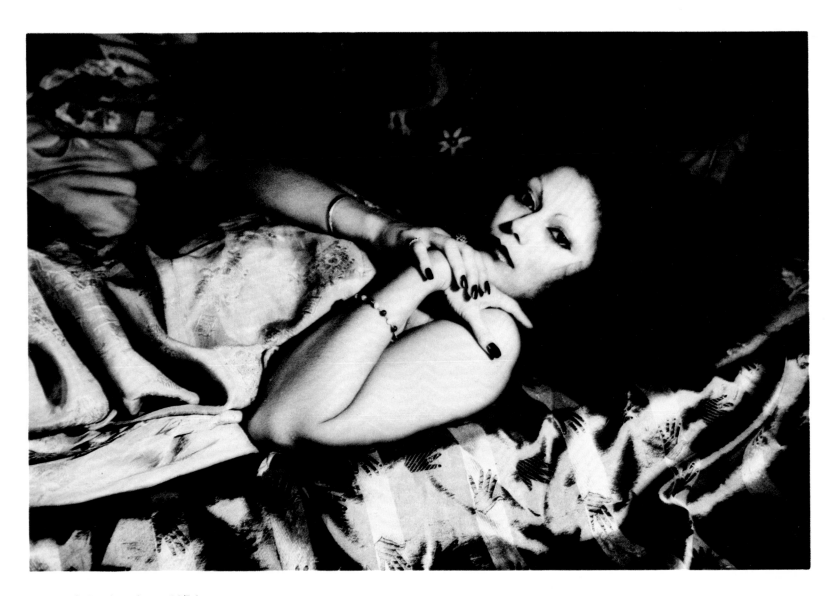

Racquel, Paris, winter 1974

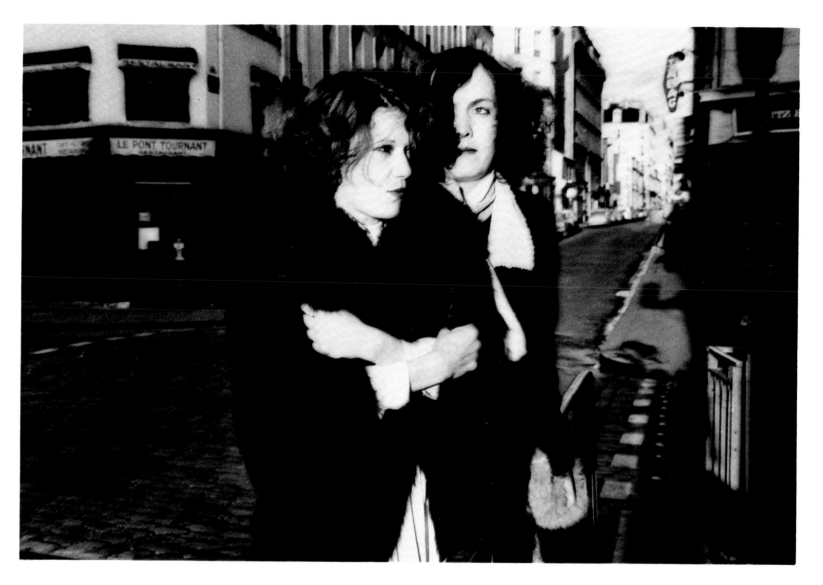

Mona and Valérie, Paris, winter 1974

(Silhouette visage,
body touching divan,
looks patiently at you
or elsewhere.
Shadow gently caresses
as hand gently caresses,
silhouette body lying
silently waiting for
caresses.)

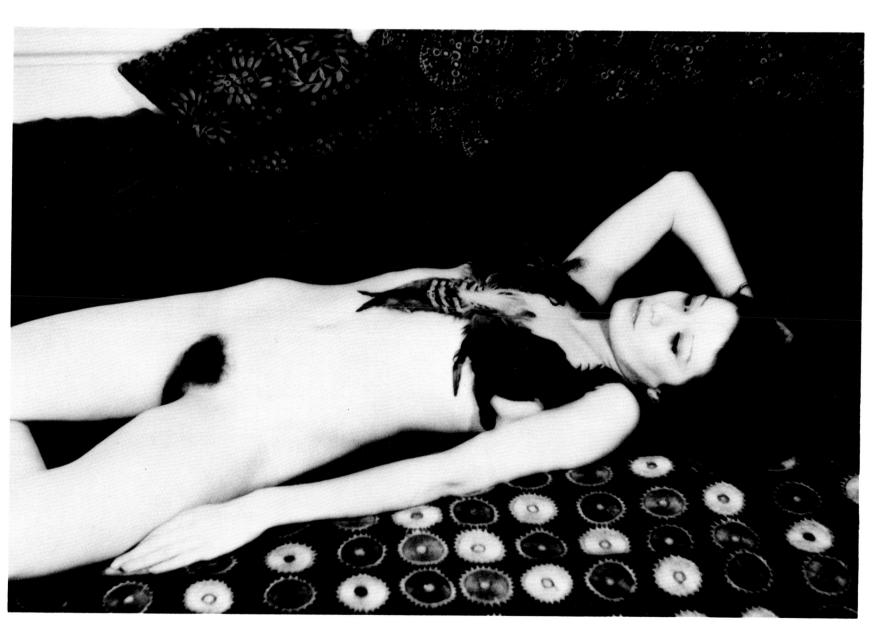

Mona, Paris, winter 1974

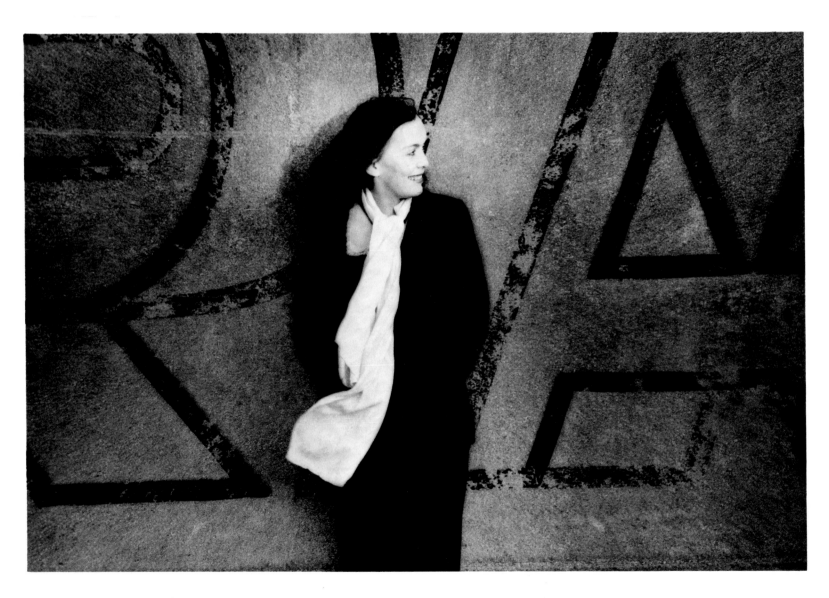

Valérie, Paris, winter 1974

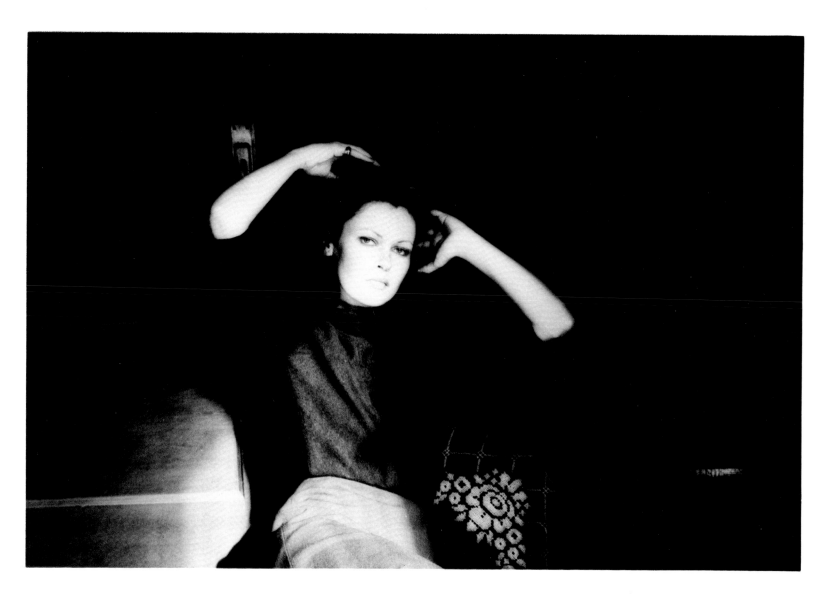

Carole, San Francisco, winter 1975

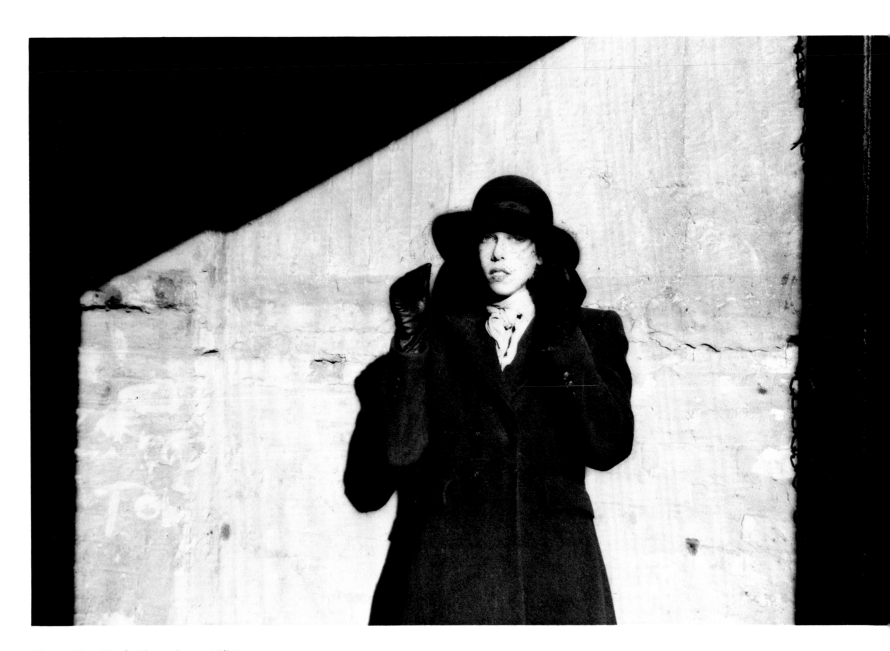

Tessa, New York City, winter 1975

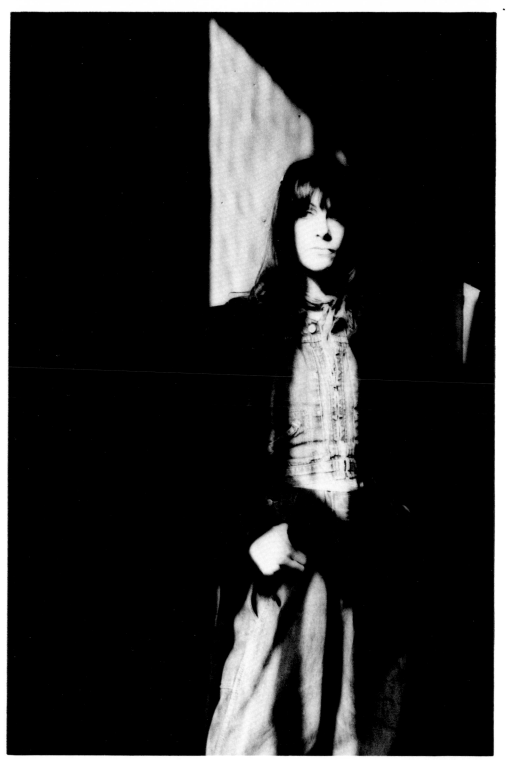

Marcia, New York City,
winter 1975

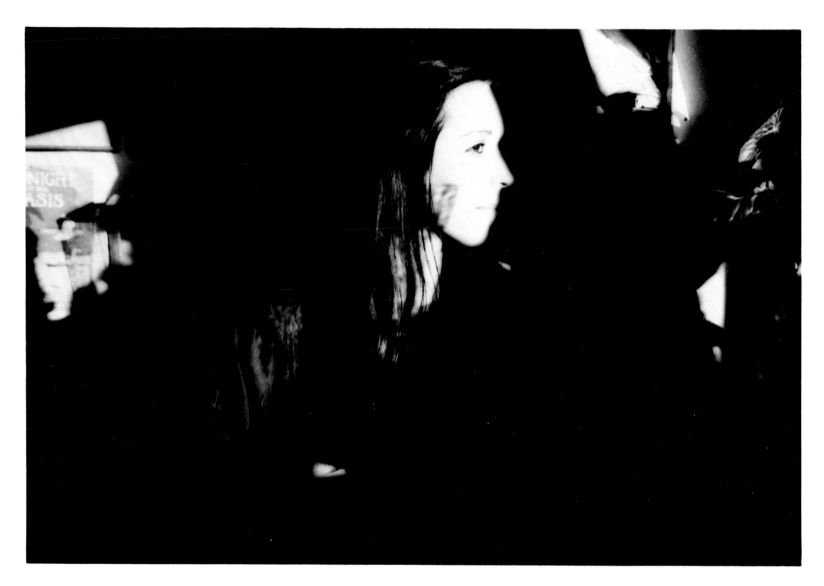

Constance, California, winter 1975

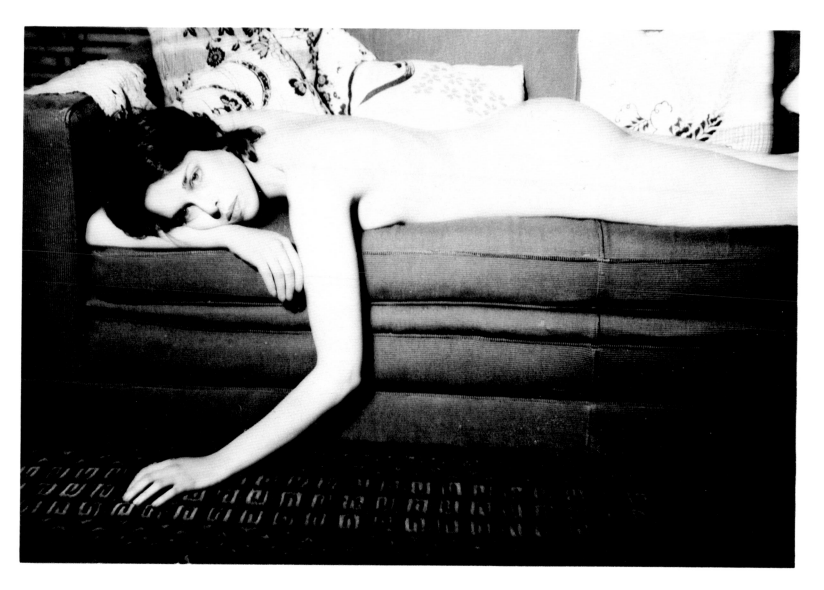

Tessa, New York City, winter 1975

Unafraid nude in a frame,
Proud and without a name,
Protruding, her well-shaped chest
Confronts you with her loveliness.

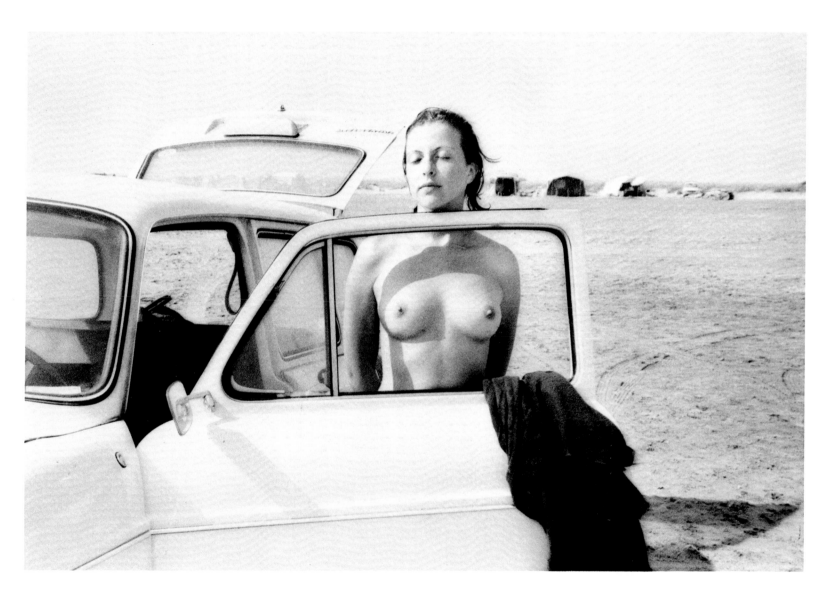

Elizabeth, Camargue, summer 1975

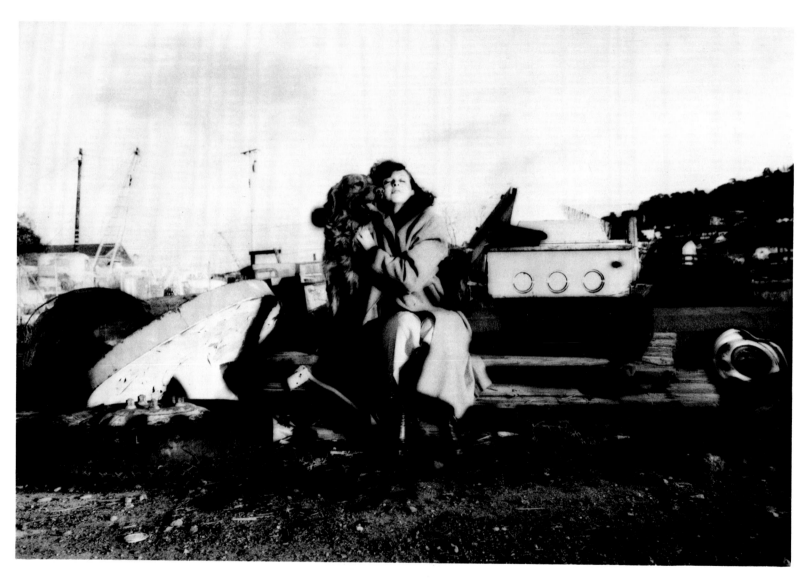

Elizabeth and Archie, California, winter 1975

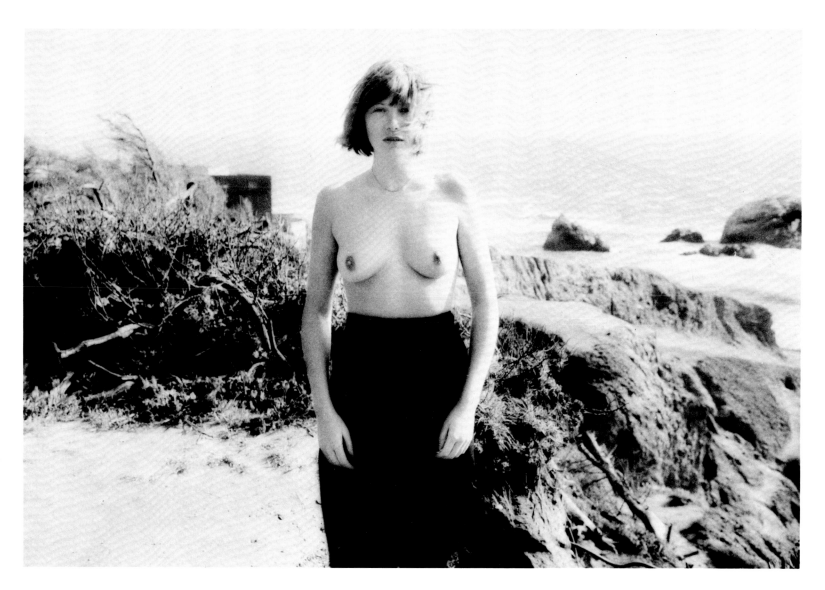

Aurore, California, spring 1975

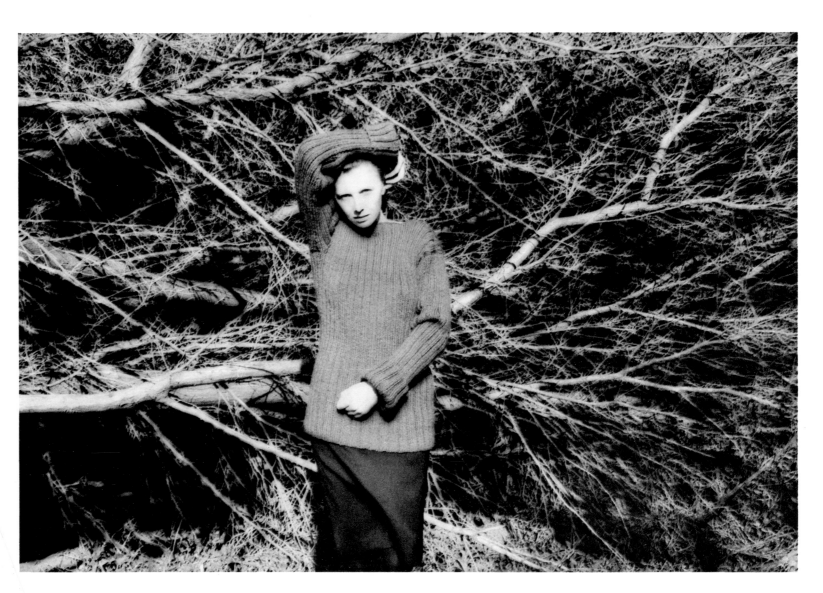

urore, California, spring 1975

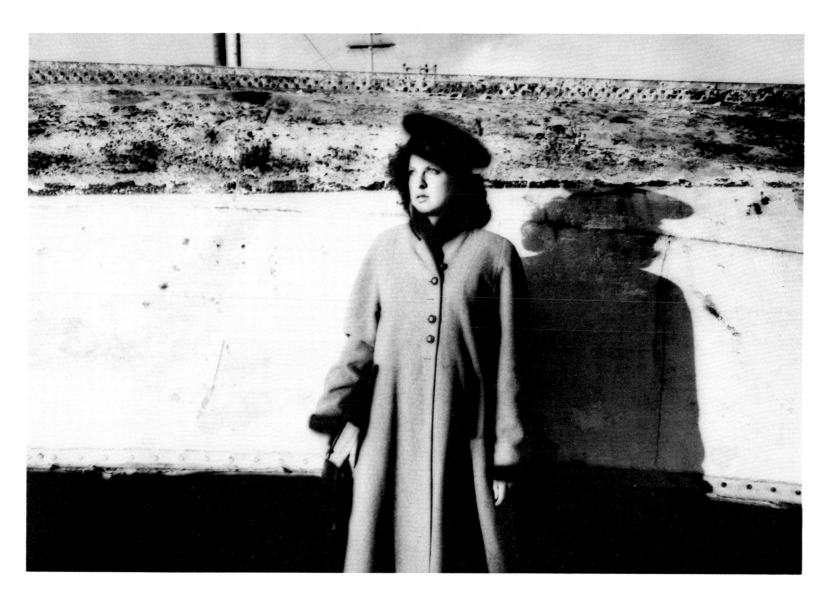

Elizabeth, California, spring 1975

Foot casually
Released from stirrup.
Boot which pleased the
Shoemaker so much,
He polished it up
Fine for her.

That night her withers
Told the blank story;
And his mane, sweeping
Jealously about,
Tortured the girl
More than her mare's
Loping gait.

Or could it have been
The stallion which
Awaited her?

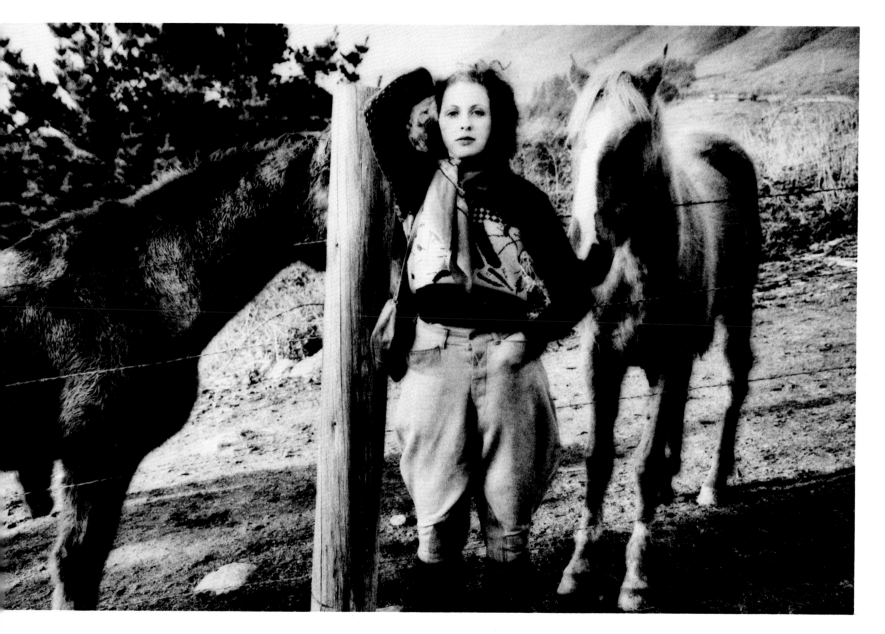

Elizabeth and Ichabod, California, winter 1975

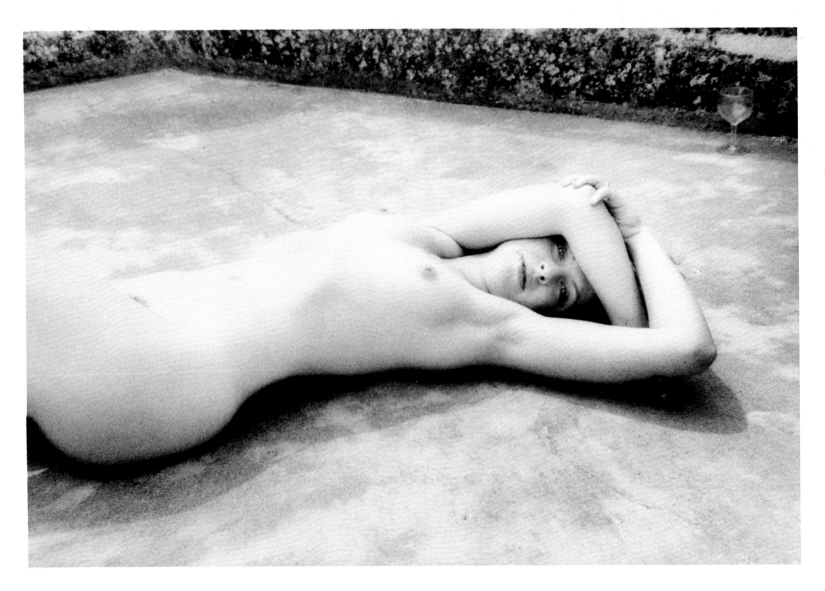

Elizabeth, Arles, summer 1975

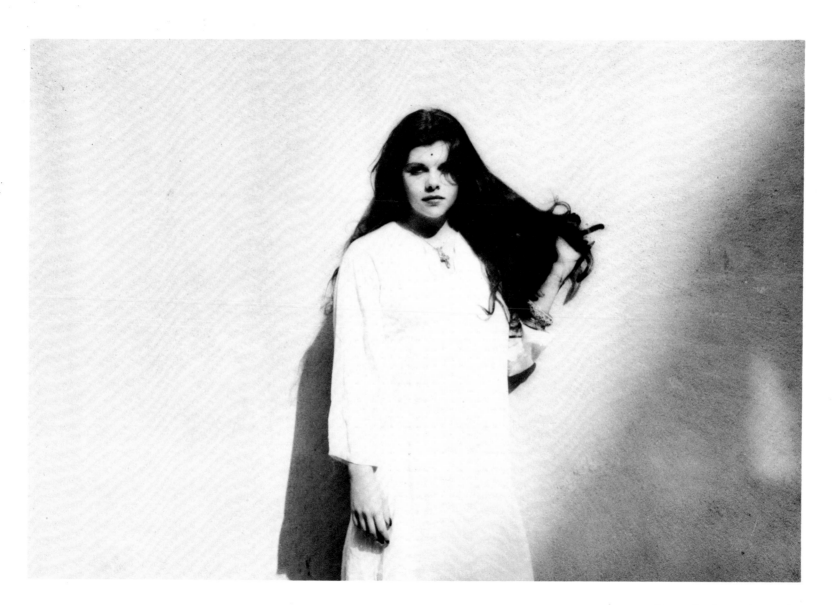

Kyra, Paris, spring 1975

Wind like branches

felt like embraces;

The three of us

closed our eyes.

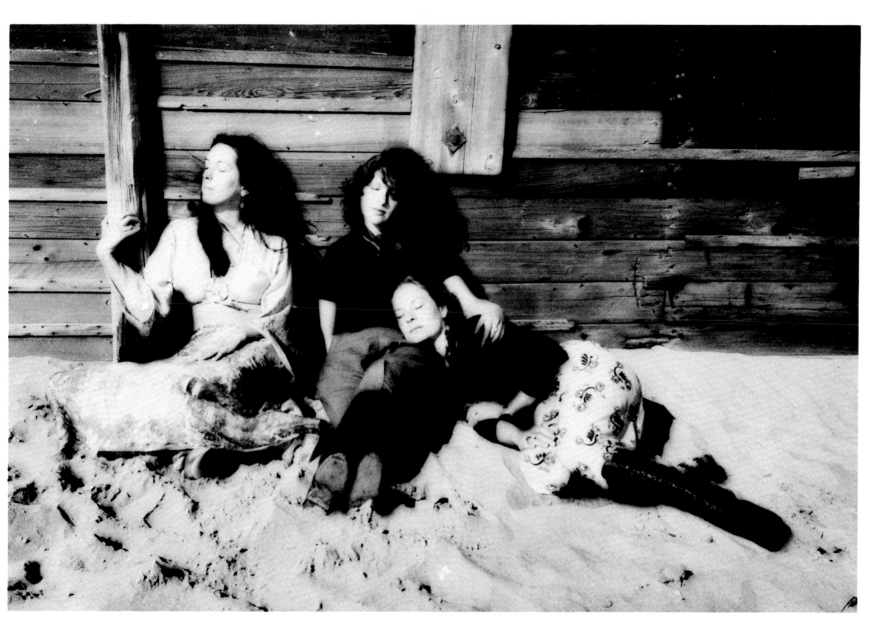

My three friends, Stinson Beach, California, spring 1975

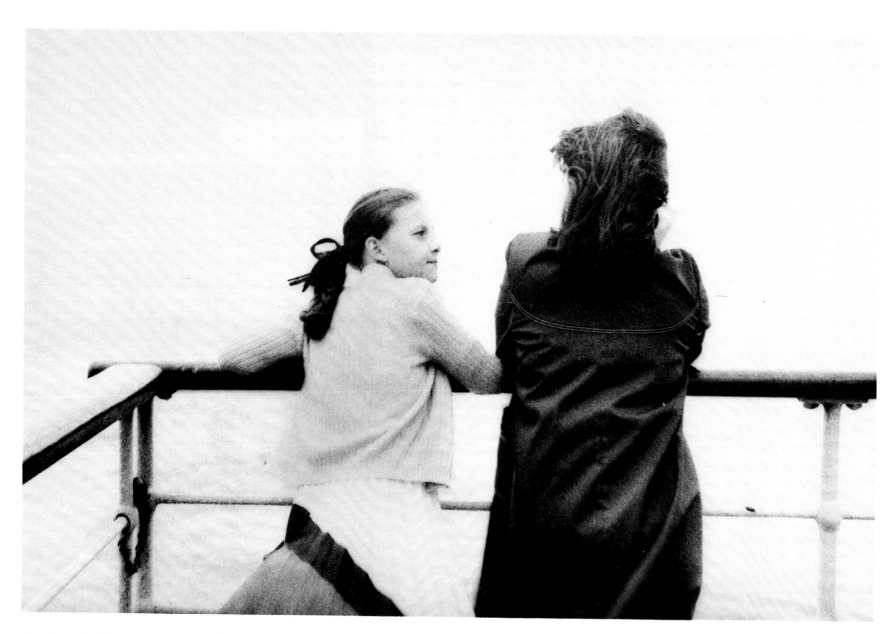

Crossing the Channel, summer 1975

Lizzie. Lizzie Lennard, the one who has been photographed. The other, Erica. Sisters. Erica, the one who has photographed. They are not twins. Three years separate them. There is no resemblance; the color of the eyes, of the hair, of the skin is different; the shape of the face, the shape of the bodies as well. Sisters somewhere else—in their movement perhaps? In a certain slowness of their movement perhaps? In their voices as well, sometimes one thinks one hears one while the other speaks; their voices are the same, the same extenuated softness, extenuating, the same tonal song. The infinite grace of this relationship: the one who photographs and the one who lets herself be taken; the one who does and the one who lets it be done; the one who reclaims a crushed immobility of the other and this other who dressed for it. How could people reach a deeper understanding than they, these sisters? The book is admirable because it translates this disparity into a dizzying harmony. A relationship which is suddenly displaced and makes its way toward others than the one called Lizzie. But why not? Lizzie then continues under other forms, with other names: the relationship is perpetuated by Erica. I see that. I see. I go. I go from Lizzie to Lizzie.

I see that Lizzie is in a French garden. I see Lizzie in 1920. I see Lizzie before the Parthenon. On a beach, but where? On a road. Lizzie and others who wait endlessly, in Dachau in front of a boarded house. And with others also, shipwrecked near a dark sea bordered by dark rocks, a Greek sea. I see that Lizzie is in front of the Aztec bas-relief of a mercury. I see it is Lizzie again in this dead automobile stopped for a very long time in the underbrush. Even though there Lizzie comes to me from another century, I am able to find her once more. Then I see her in the sun, eyes closed, closed by Erica, beside a sea without identity.

I see everything clearly: the long and complicated journey

around the world. When? A hundred years ago? And this return toward the voyage, this time taken by the children, the endless voyage between Europe and America, this incessant coming and going in the cage of the world. I see it in the photography of Erica: the inscription of a latent tragedy, always there, in each photograph, in the sky above women, in the sea. The space here, whatever it may be, is one of relative voyage, respite.

Marguerite Duras

NOTE

*All the photographs in this book were taken with a
LEICA M-3, using a 50mm lens in available light.
The film was developed in Rodinal, and the prints were
made on a Leitz focomat enlarger.*